Art Cards for Baby:

14 Red, Black and White Images to Create Your Own Infant Stimulation Cards for Babies

Simone Novelette

Copyright © 2017 Simone Novelette
All rights reserved.

Introduction and Instructions

I have tried to make this book as versatile as possible. There are many ways you can use it to stimulate your baby's vision and help brain development.

1. It is bound because you may decide that you want to use it as an art book for your baby and show him or her the pictures one at a time.

2. You can cut out the pages because nothing is printed on the back of them.

-- Create mobiles to hang over a crib when you paste them on thicker paper for sturdiness.
-- Cut out the images and tack them to a wall in the nursery, playroom or play area.
--Frame and hang them on the nursery wall.
--Cut them out, back them on sturdy paper and hang them on a line in the nursery.
--Make an art board that you can lay on the ground or against a wall where your baby crawls or has tummy time.
--Laminate them and give them to your baby.

It is up to you how you want to use the images to stimulate your baby's vision, memory and brain. There are 10 red, black and white animal images and a bonus of 4 black and white abstract images.

Other books by Simone Novelette:

Teach your child the letters and sounds of the alphabet, while showing them stunning pictures of animals. Tell them fun and unusual facts about each animal from A-Z with this unique book!

Perhaps the greatest gift we can give our children is our prayers and well wishes. This inspirational book is designed to help moms to relax, color and pray for their children. 27 inspirational coloring images along with 27 powerful prayers for your child inside!

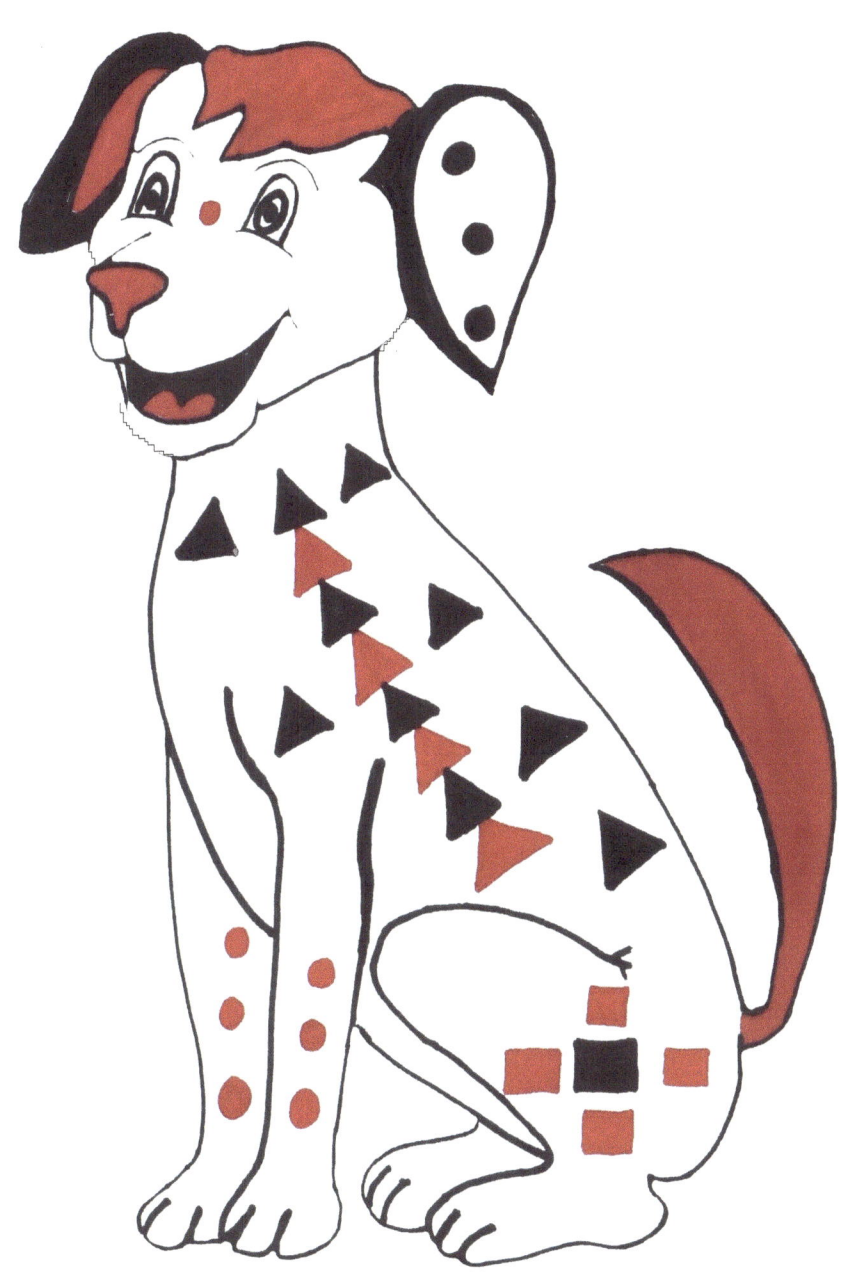

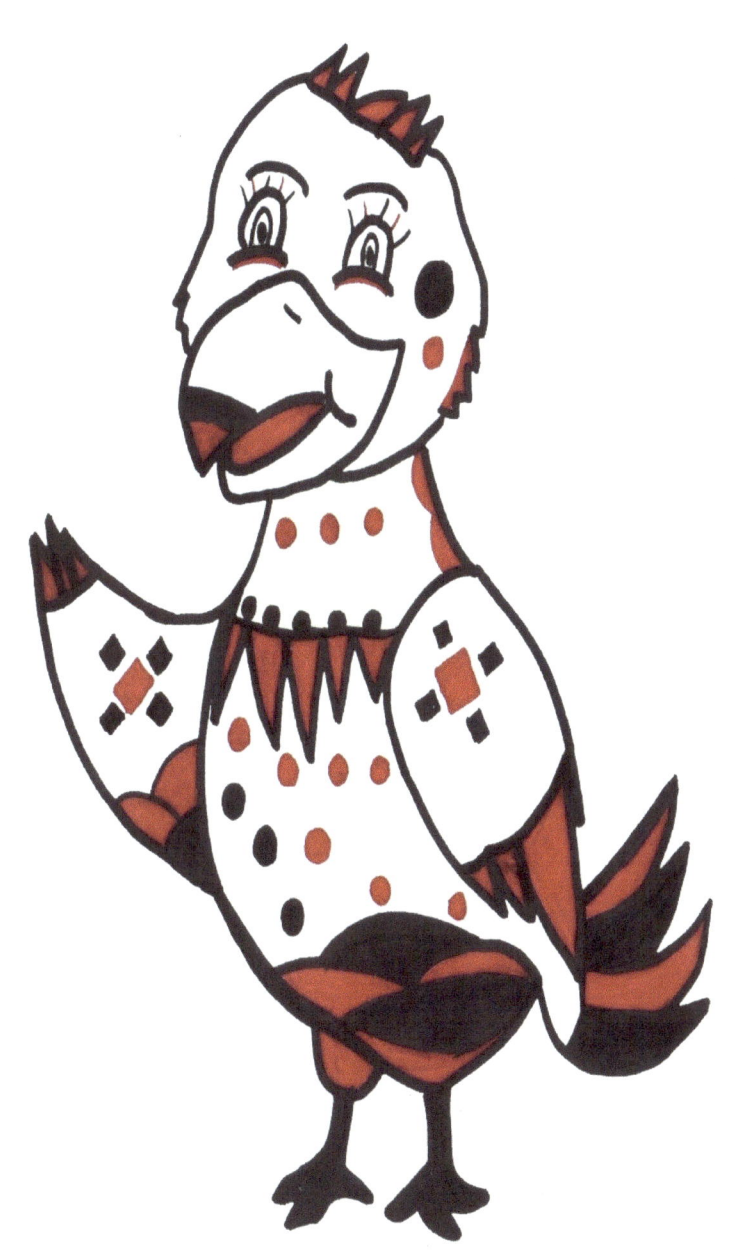

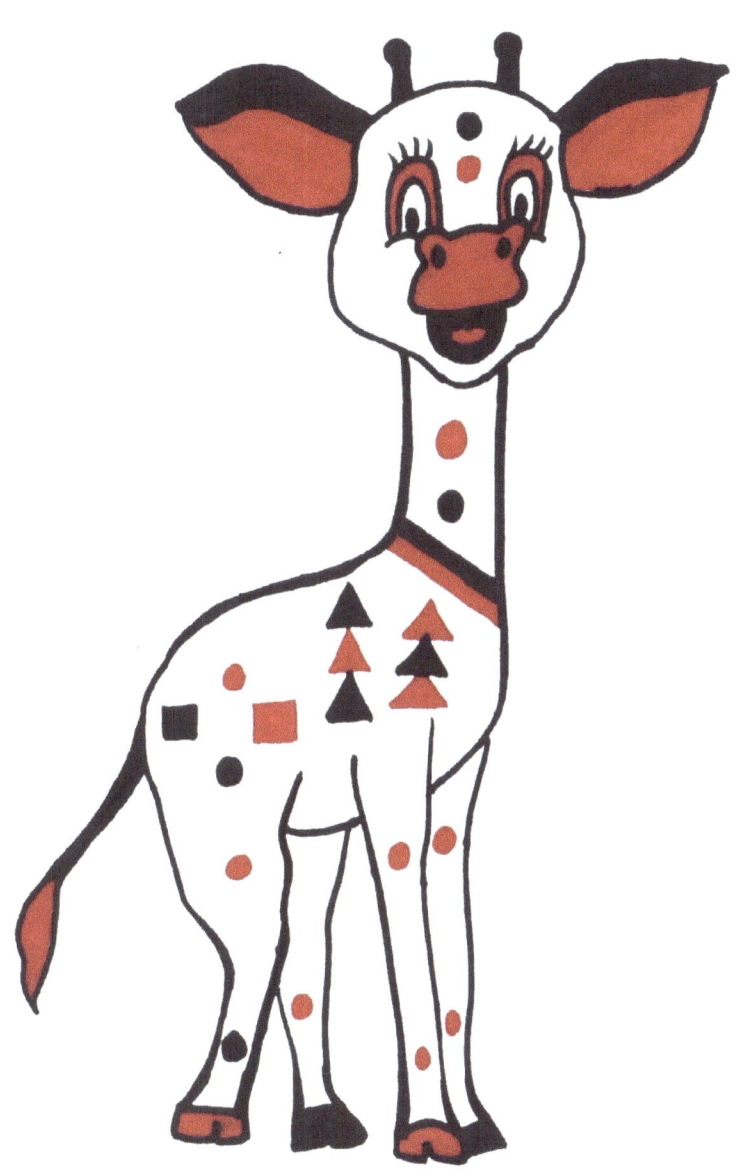

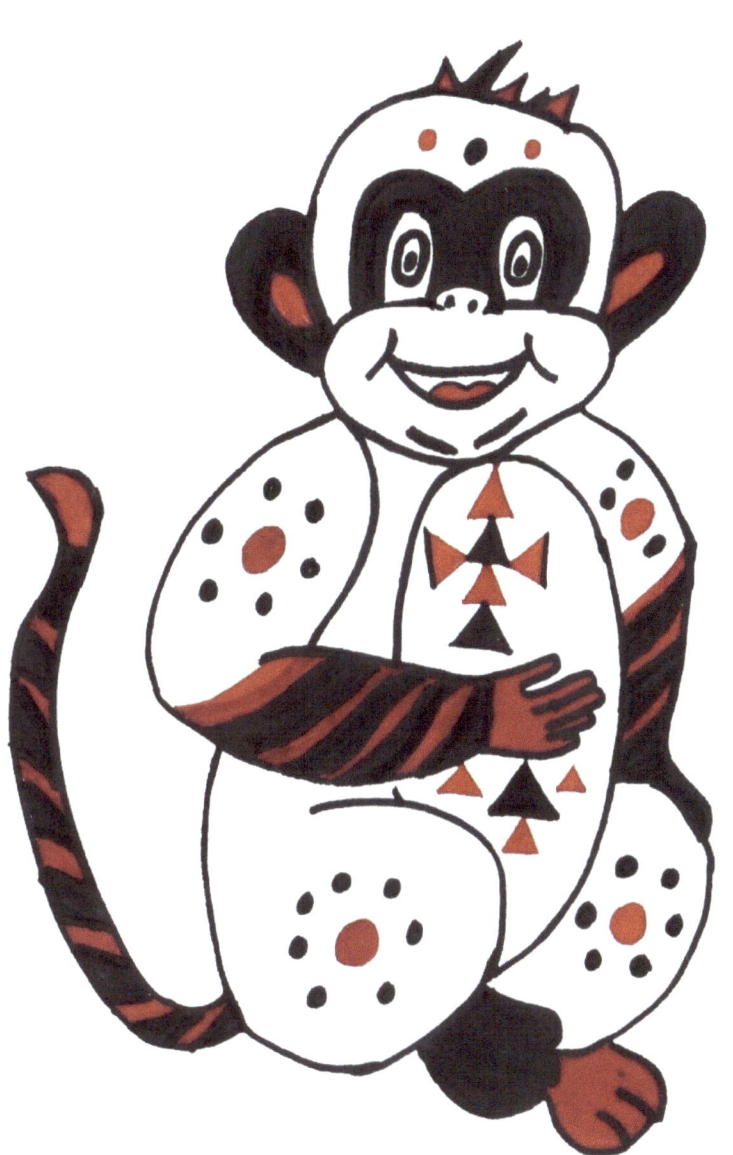

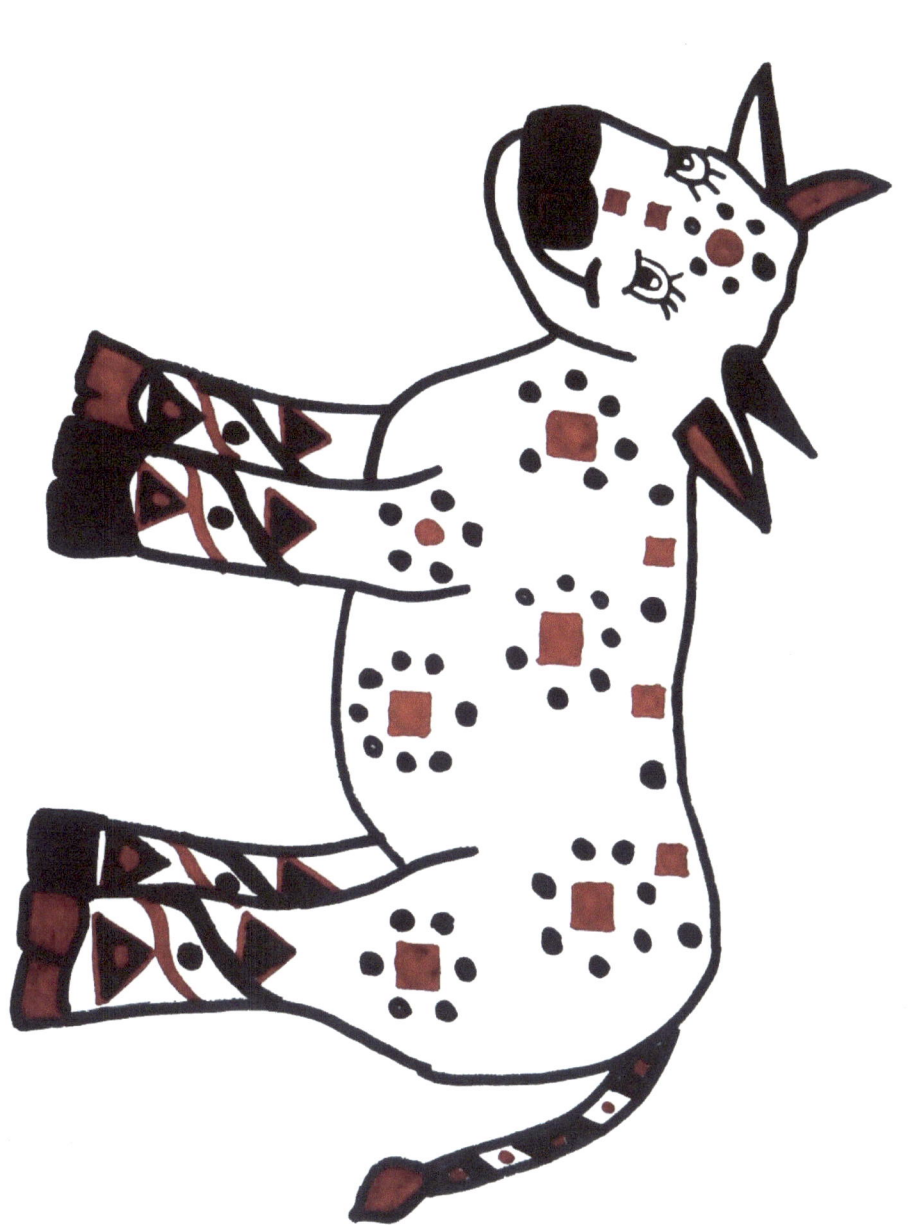

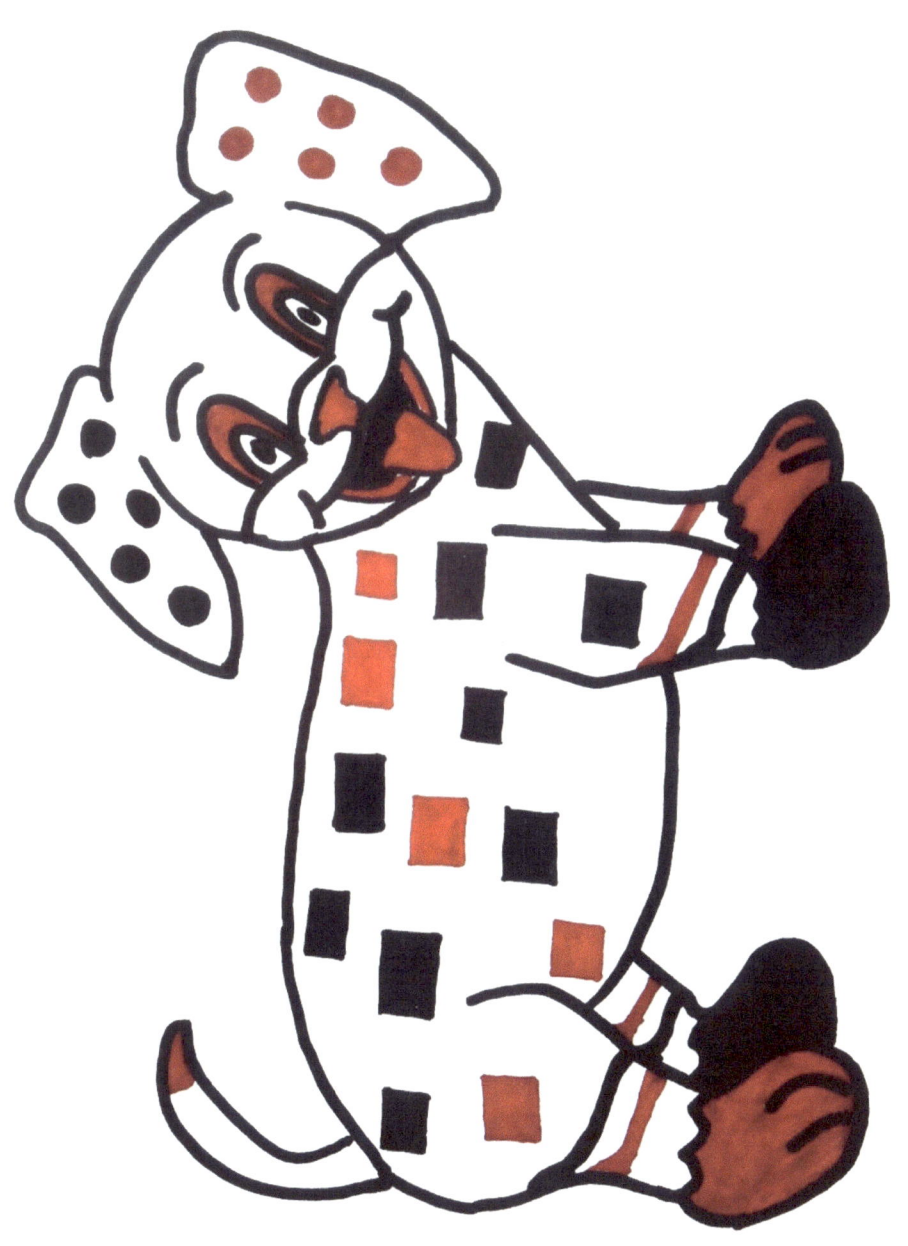

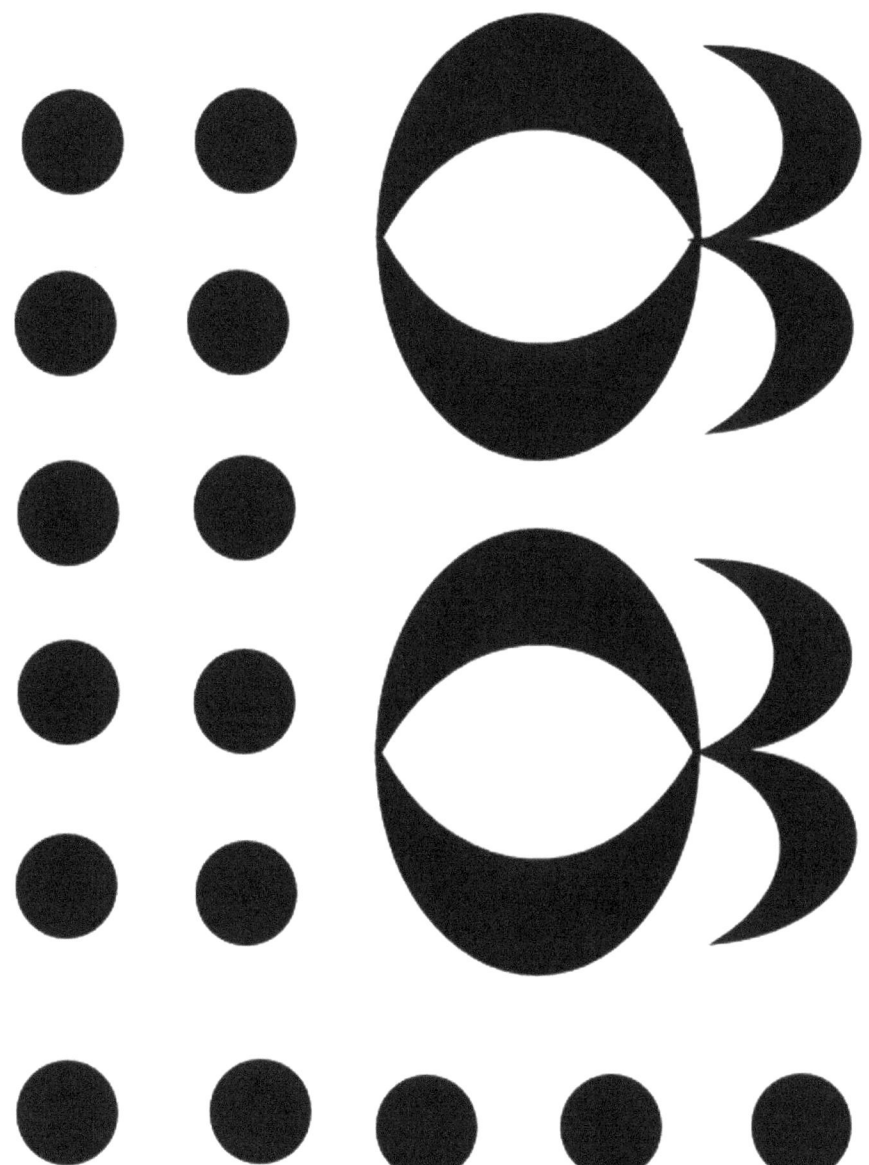

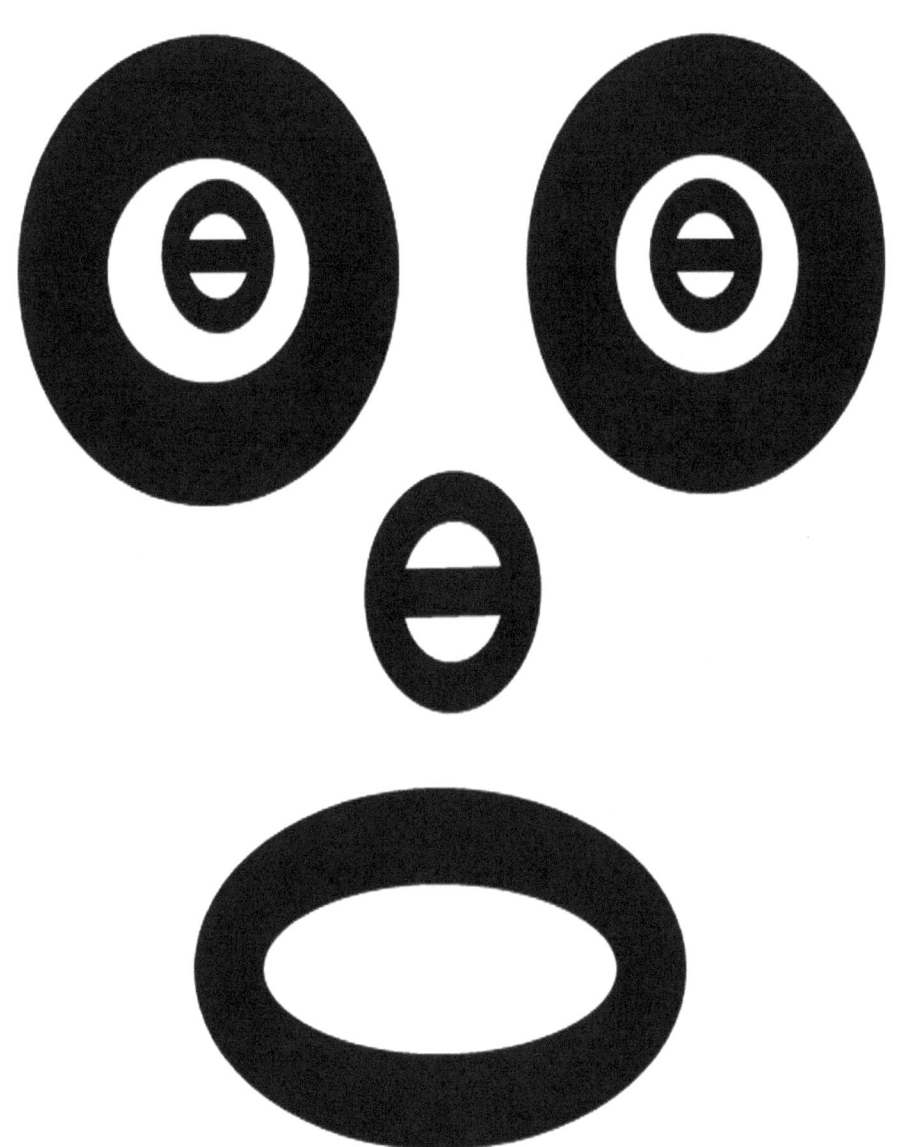

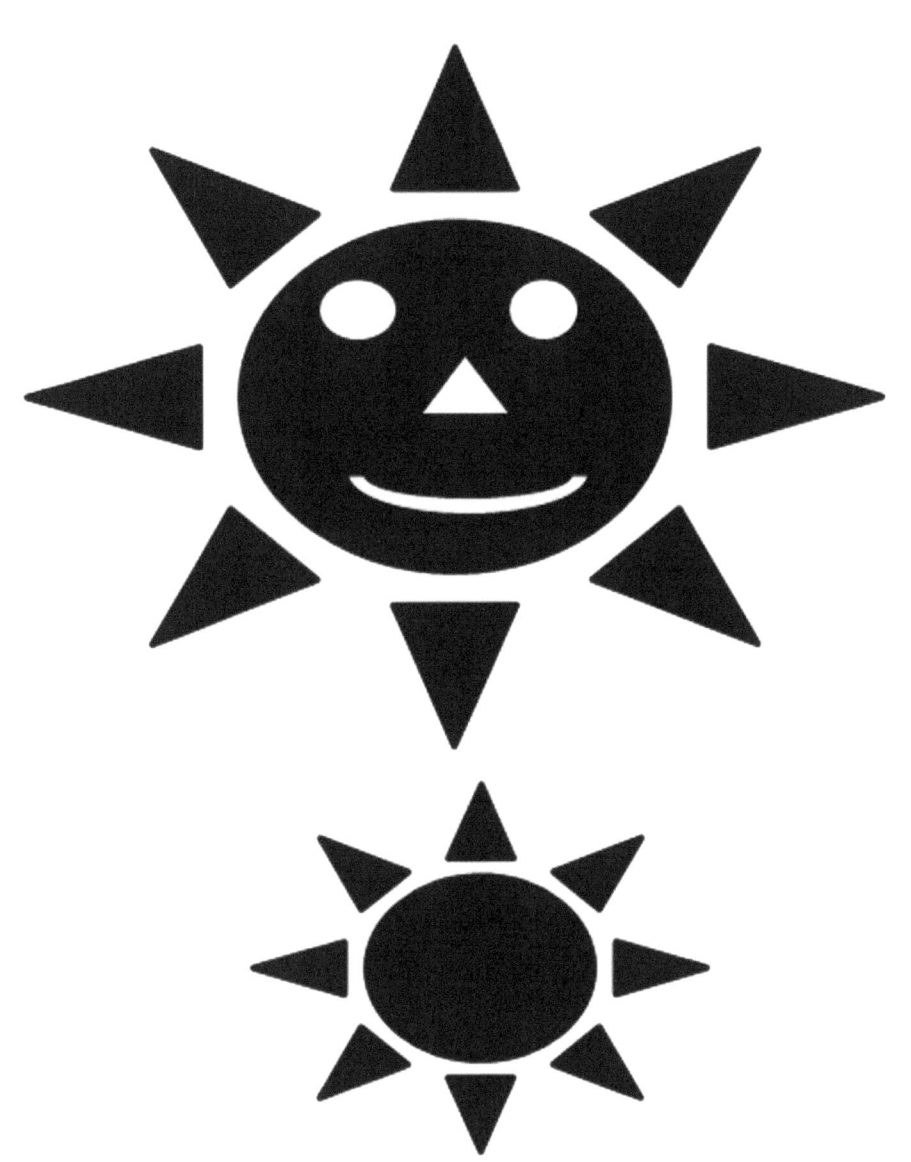

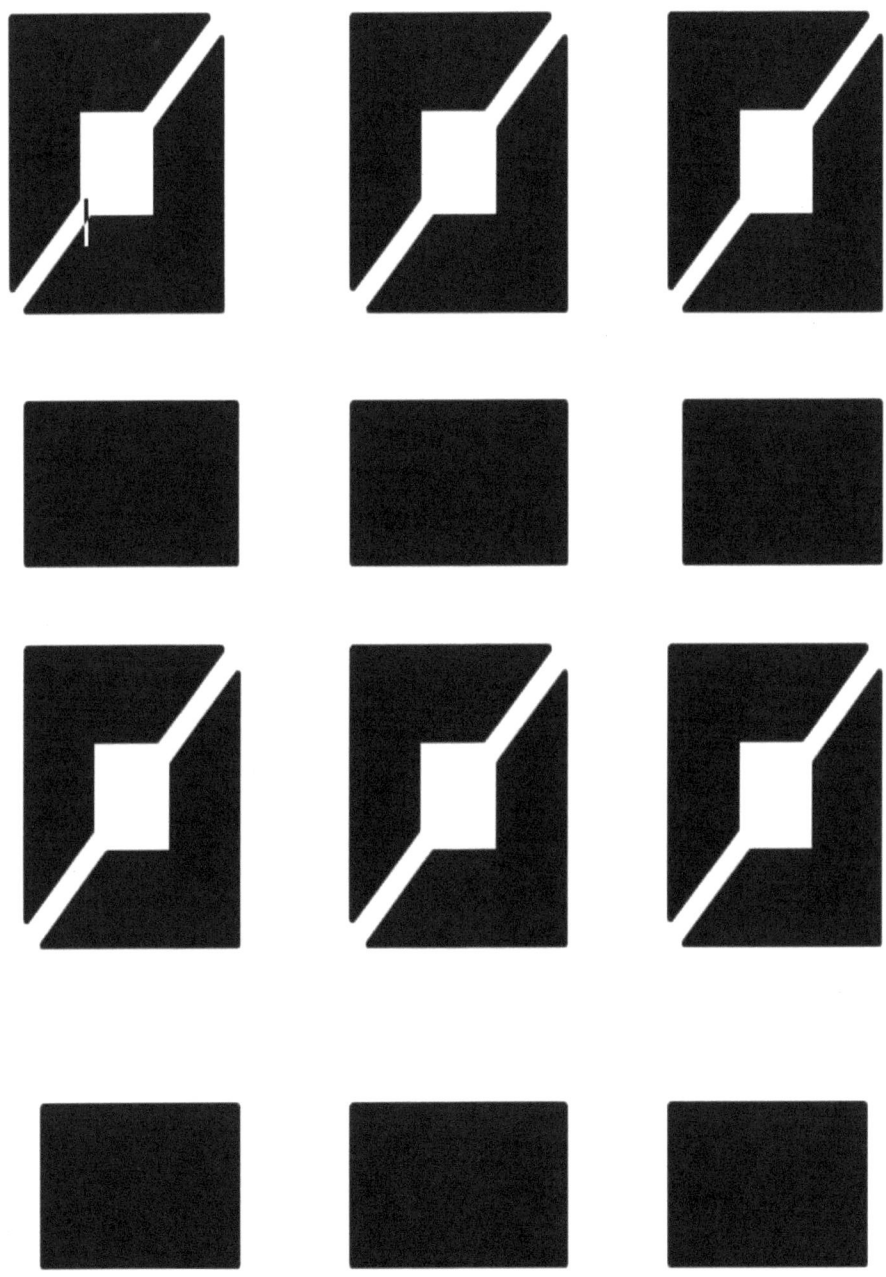

www.ingramcontent.com/pod-product-compliance
Lightning Source LLC
Chambersburg PA
CBHW041302180526
45172CB00003B/940